Jessica,

This book reminded me of something that you would love. When you get homesick for "up north trees" just open these pages and you'll be able to reflect back home.

Love you so much.

Love,

Mom

(Xmas 2005)

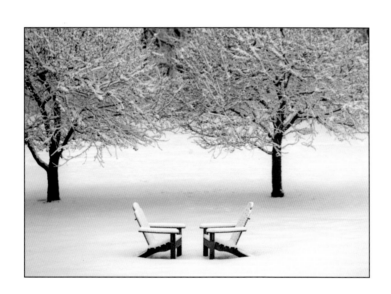

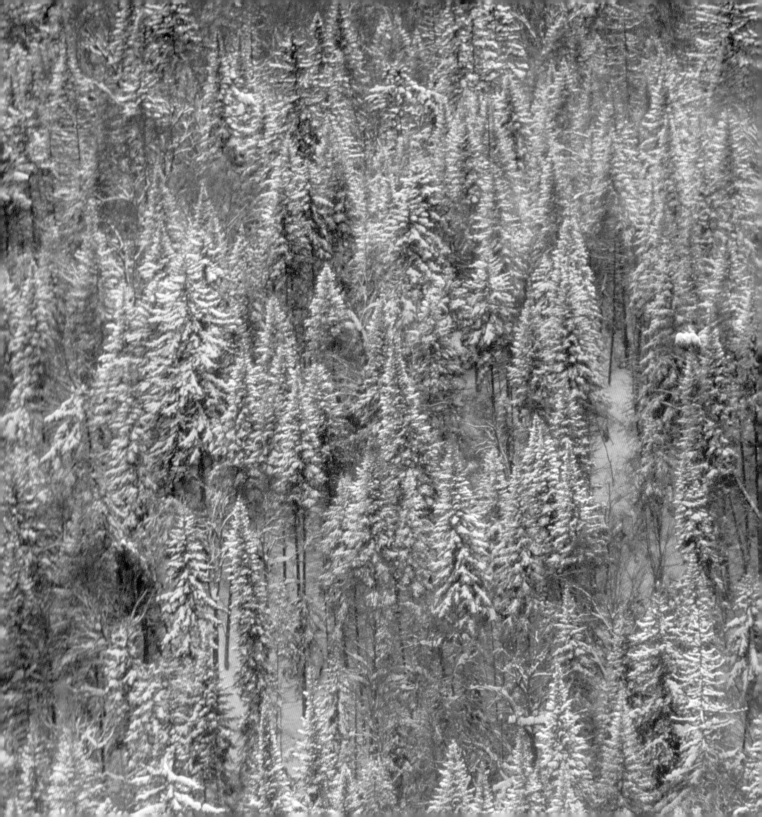

Silent Moments

Photography by Scott Barrow

COURAGE BOOKS

AN IMPRINT OF RUNNING PRESS
PHILADELPHIA • LONDON

© 2005 by Running Press
Photography © 2005 by Scott Barrow
All rights reserved under the Pan-American and International
Copyright Conventions
Printed in China

9 8 7 6 5 4 3 2 1
Digit on the right indicates the number of this printing

Library of Congress Control Number: 2005902149

ISBN 0-7624-2457-5

Cover and interior design by Corinda Cook
Edited by Jennifer Leczkowski
Photo research by Susan Oyama
Typography: Caslon, Granjon, Linoscript and Helvetica Neue

This book may be ordered by mail from the publisher.
But try your bookstore first!

Published by Courage Books, an imprint of
Running Press Book Publishers
125 South Twenty-second Street
Philadelphia, Pennsylvania 19103-4399

Visit us on the web!
www.runningpress.com

Contents

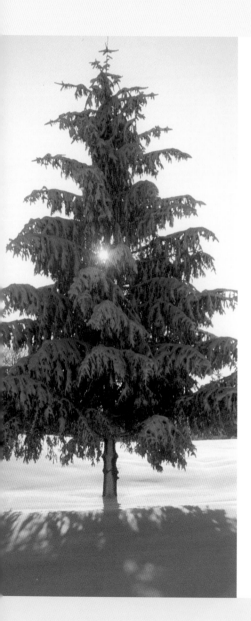

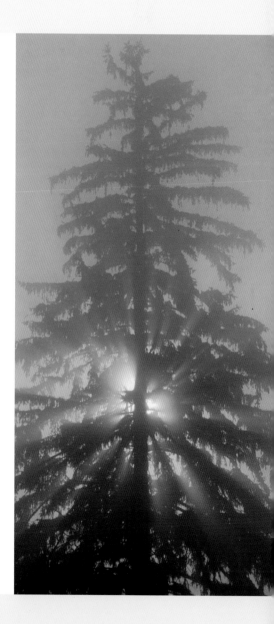

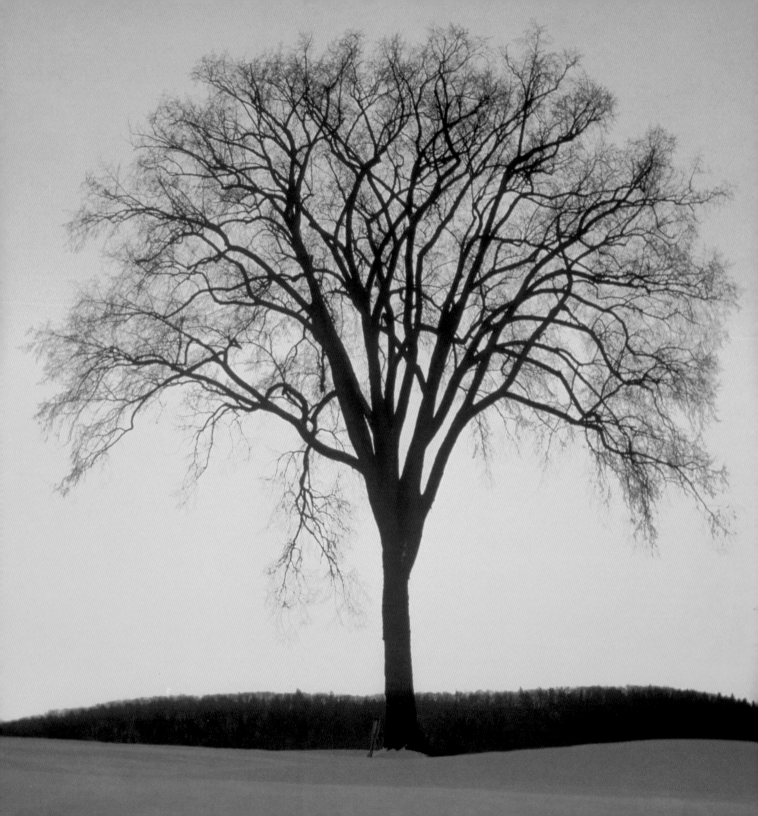

Introduction

A beautiful season of tranquility and introspection, winter gives us the opportunity to slow down and appreciate the quiet subtleties of nature—the calming whisper of a chill wind, the seamless white blanket of a newly-fallen snow, the starlit sky of a cold, clear night—calling us to reflect upon ourselves in the midst of these special and private moments. It is a time of resting and waiting; a time for remembering the glory of the autumn past and anticipating the excitement of spring; a time for personal revelation and understanding.

The book you hold is an evocative collection of breathtaking photographs, which capture the hidden beauty of winter. The images, highlighted by insightful and thought-provoking ruminations from distinguished notables—from Ralph Waldo Emerson to Norman Vincent Peale, Henry David Thoreau to Andrew Wyeth—inspire peace and reflection, and serve as a soothing antidote to the stress of the day. So snuggle up with a blanket, sip a hot cup of cocoa, and enjoy nature in its period of rest with these exhilarating glimpses into the inner life of this inspiring season.

Reflection

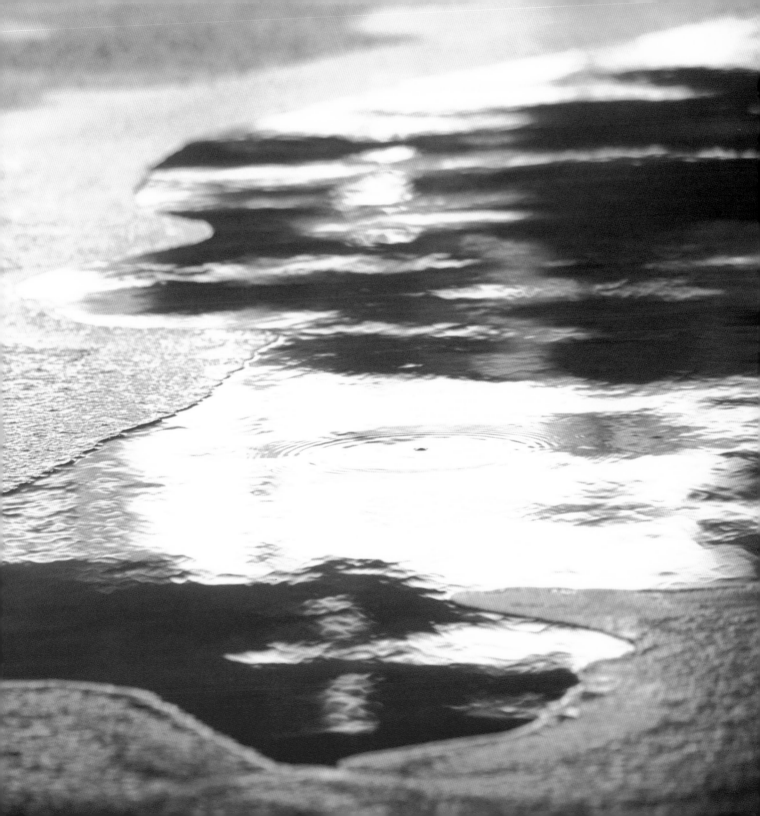

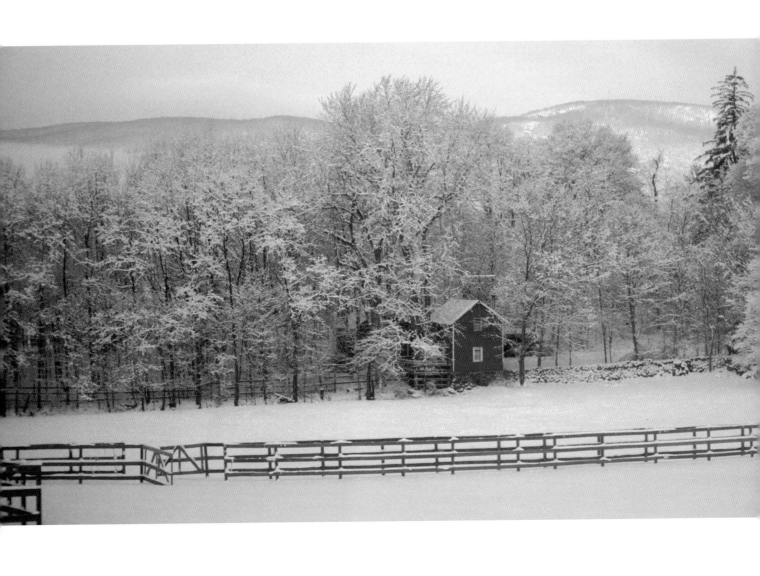

There is a privacy about it which no other season gives you . . . In spring, summer, and fall people sort of have an open season on each other; only in the winter, in the country, can you have longer, quiet stretches when you can *savor* belonging to yourself.

—*Ruth Stout (1884–1980)*
American author and organic gardener

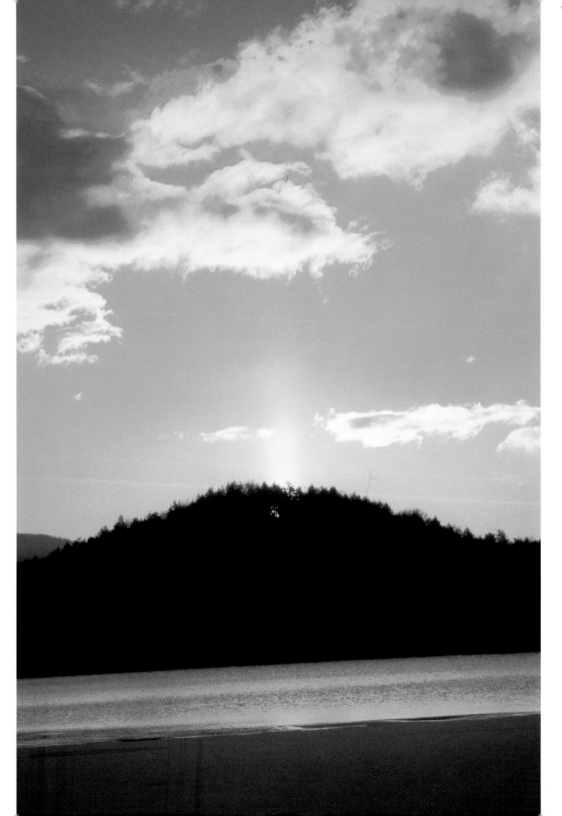

We are what we think.
 All that we are arises with our thoughts.
 With our thoughts, we make the world.

—Siddhartha Guatama [The Buddha] (c. 563–483 B.C.)

Spring, summer, and fall fill us with hope;
winter alone reminds us of the human condition.

—Mignon McLaughlin (b. 1915)
 American author and editor

One of the greatest moments in anybody's developing experience is when he no longer tries to hide from himself but determines to get acquainted with himself as he really is.

—*Norman Vincent Peale (1898–1993)*
 American cleric and writer

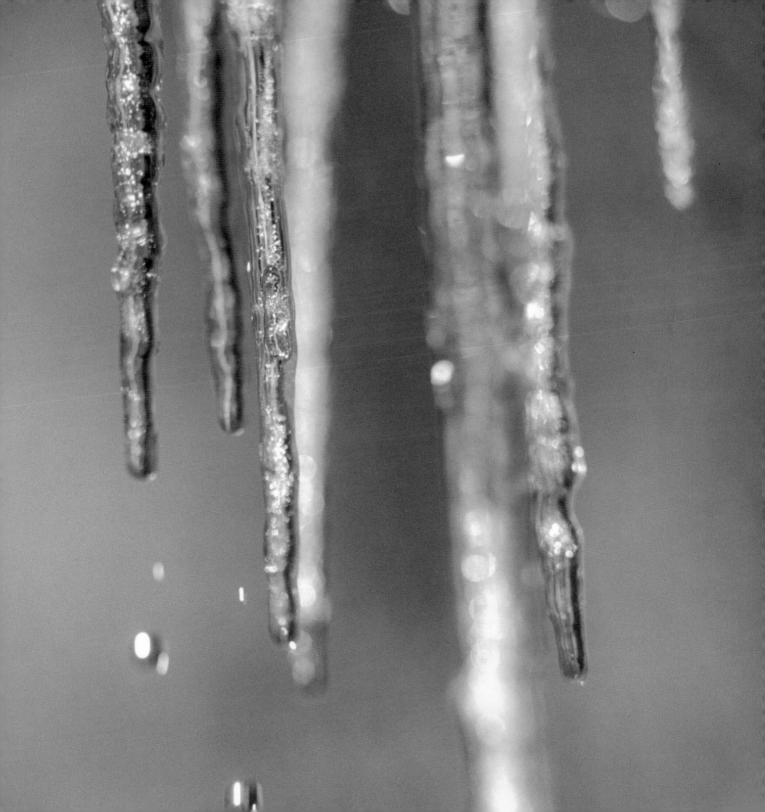

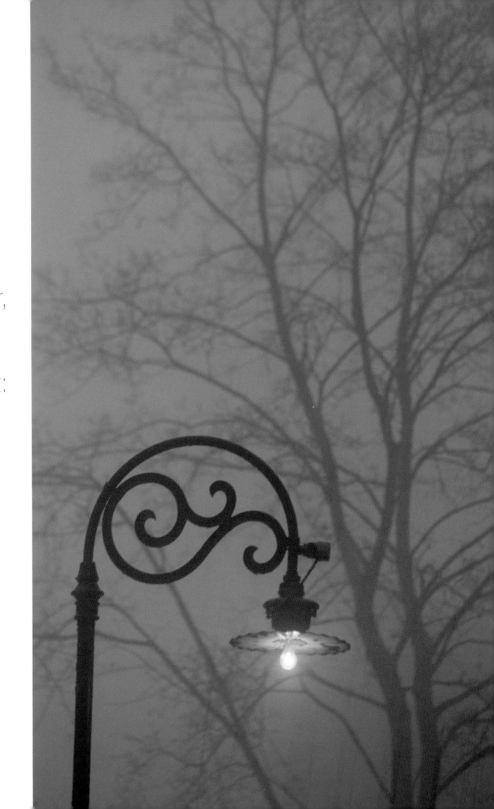

If we had no winter,
the spring would
not be so pleasant:
if we did not
sometimes taste
of adversity,
prosperity
would not be
so welcome.

—Anne Bradstreet
(c. 1612–1672)
American poet

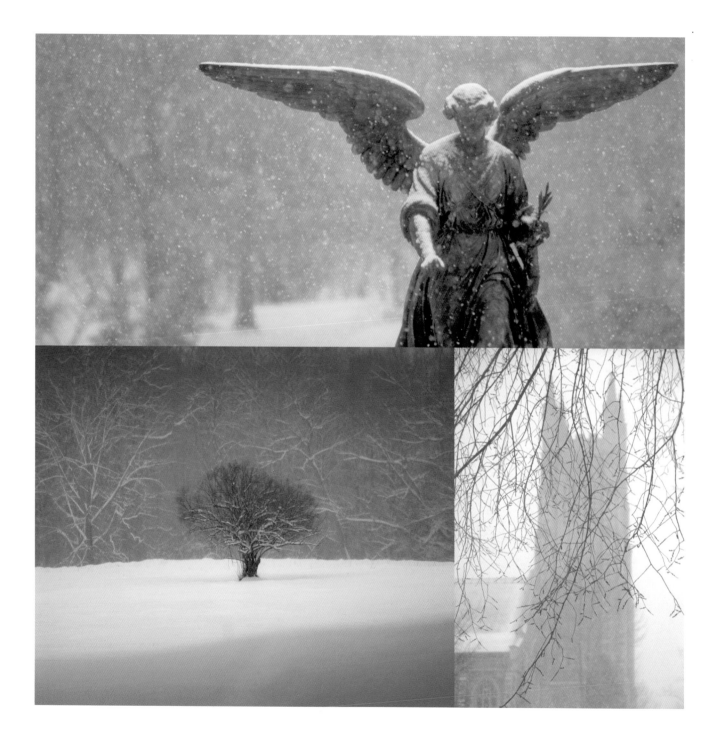

Take time to gather up the past so that you will be able to draw from your experience and invest them in the future.

—Jim Rohn
American author and lecturer

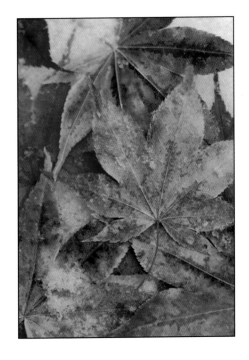

The more faithfully
you listen to the
voice within you,
the better you
will hear what is
sounding outside.

—Dag Hammarskjöld (1905–1961)
Swedish statesman

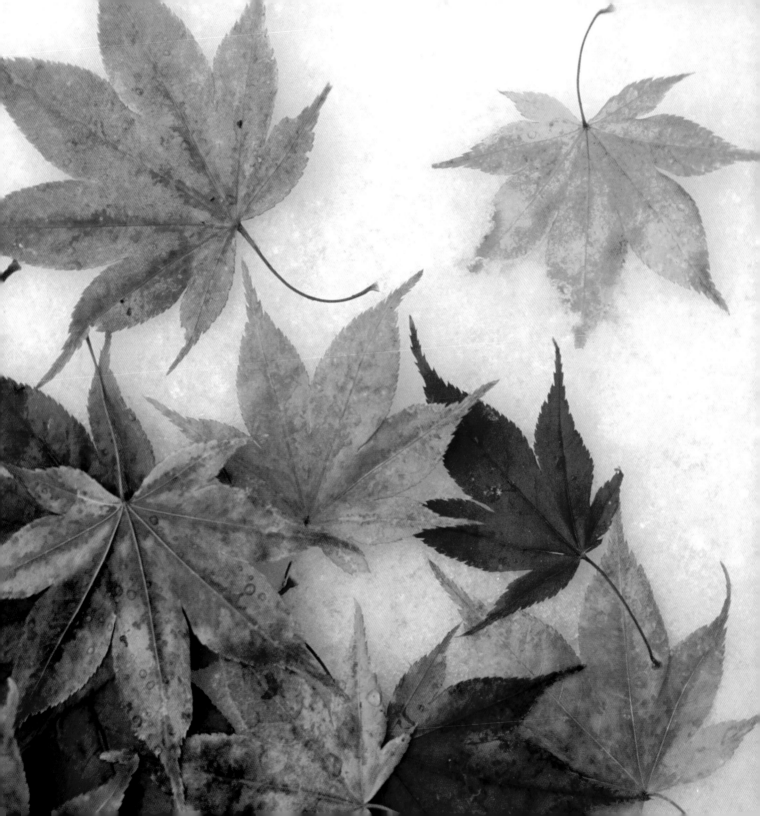

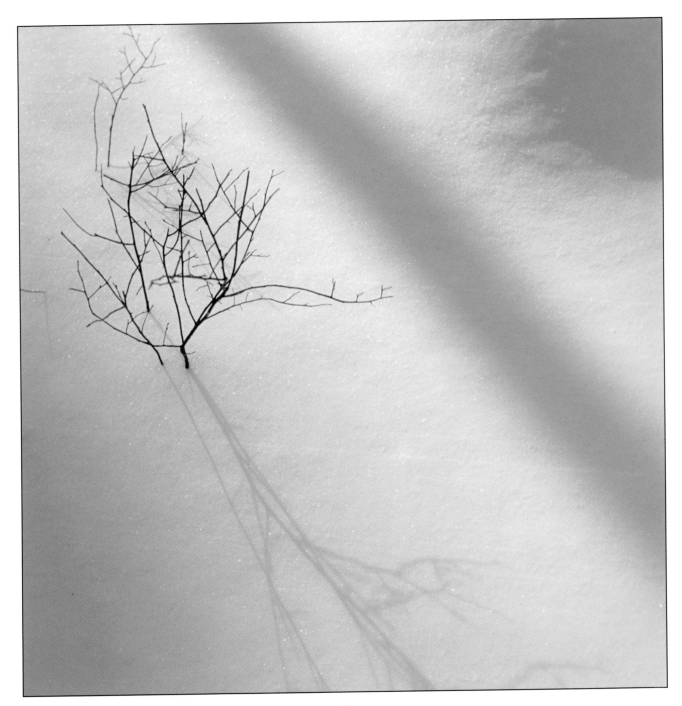

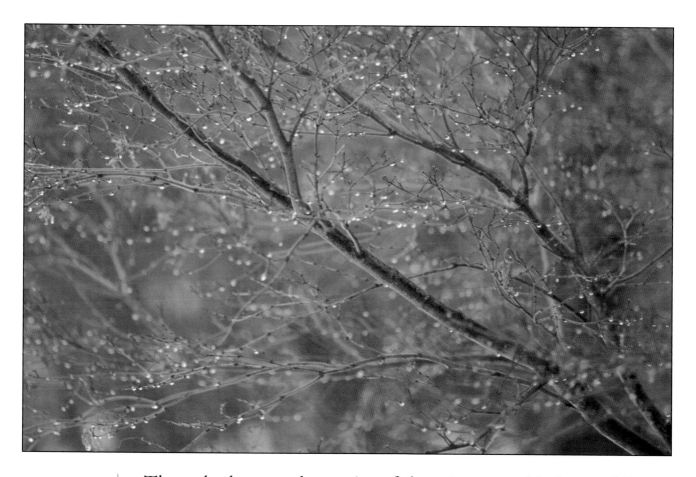

The nakedness and asperity of the wintry world always fills the beholder with pensive and profound astonishment: as the variety of the scene is lessened, its grandeur is increased; and the mind is swelled at once by the mingled ideas of the present and the past . . .

—*Samuel Johnson (1709–1784)*
 English author

Like water which can clearly mirror the sky

and the trees only so long as its surface is undisturbed,

the mind can only reflect the true image

of the Self when it is tranquil and wholly relaxed.

—Indra Devi

20th-century Russian-born American writer

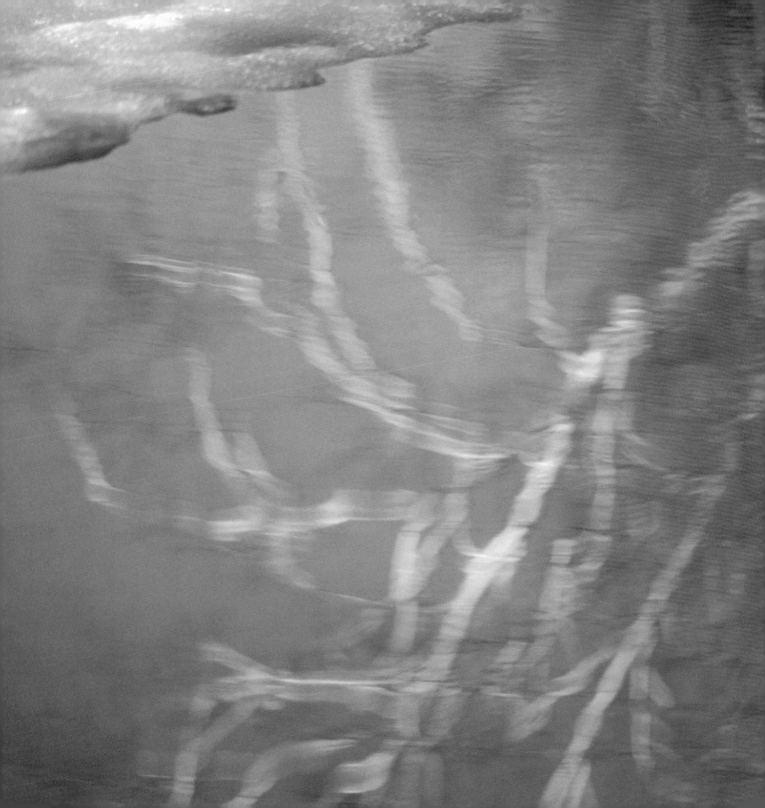

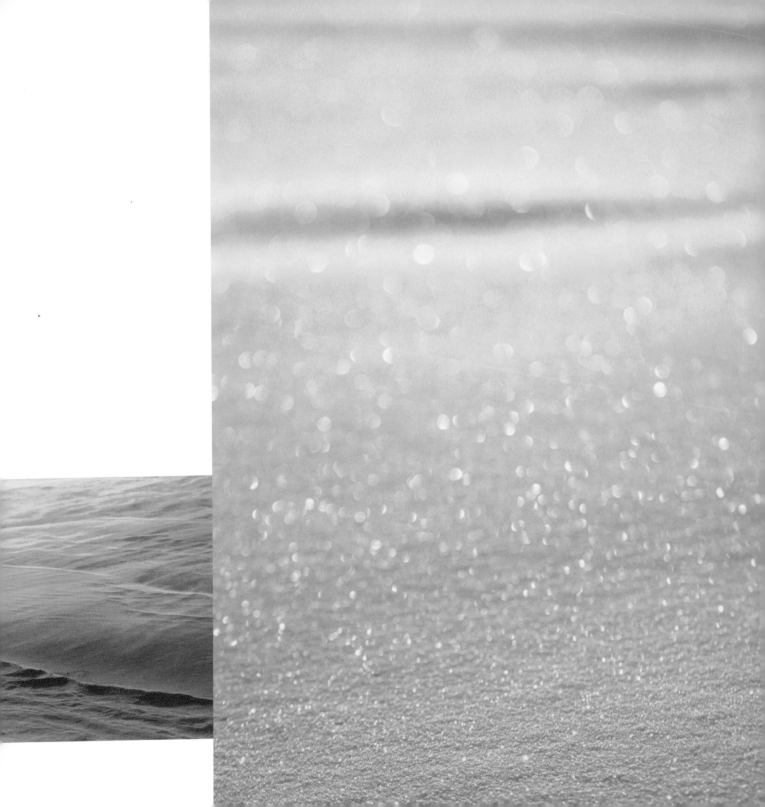

Happiness is reflective, like the light of heaven.

—Washington Irving (1783—1859)

American writer and poet

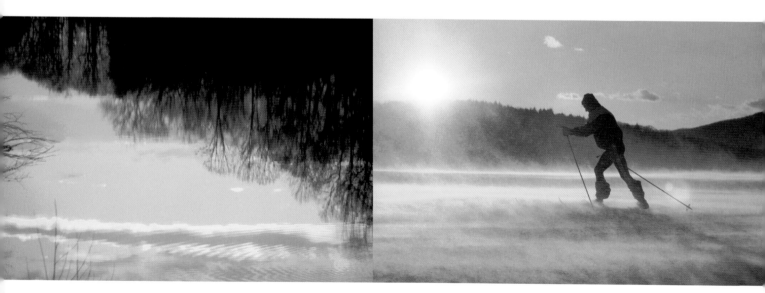

Transcendence

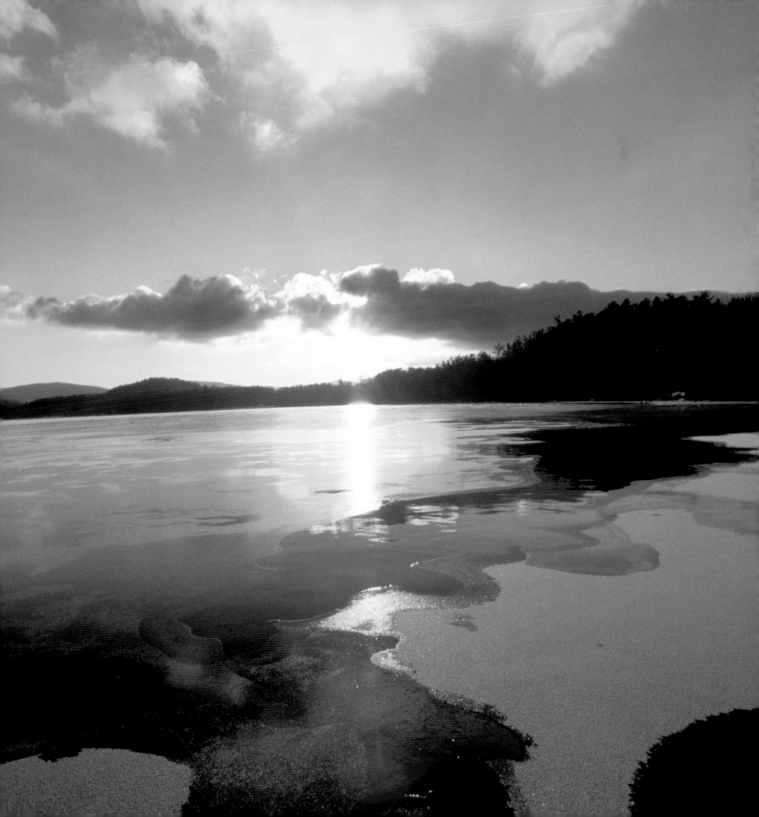

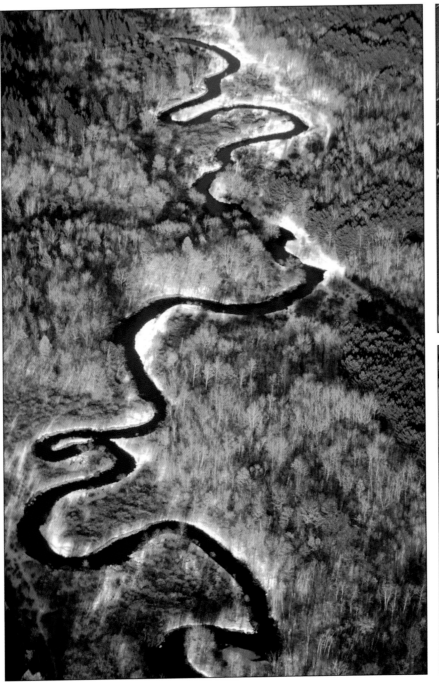
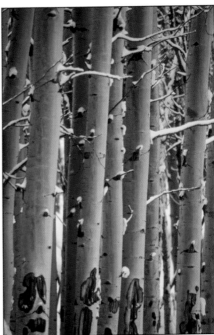
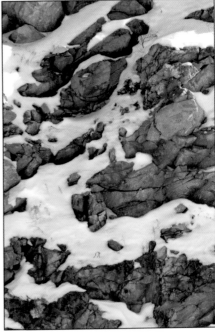

I prefer winter and fall,
when you feel the bone structure
in the landscape . . .
Something waits beneath it,
the whole story doesn't show.

—Andrew Wyeth (b. 1917)
American realist painter

We must walk in balance
on the earth—a foot in spirit
and a foot in the physical.

—Lynn Andrews

20th-century American writer and shaman

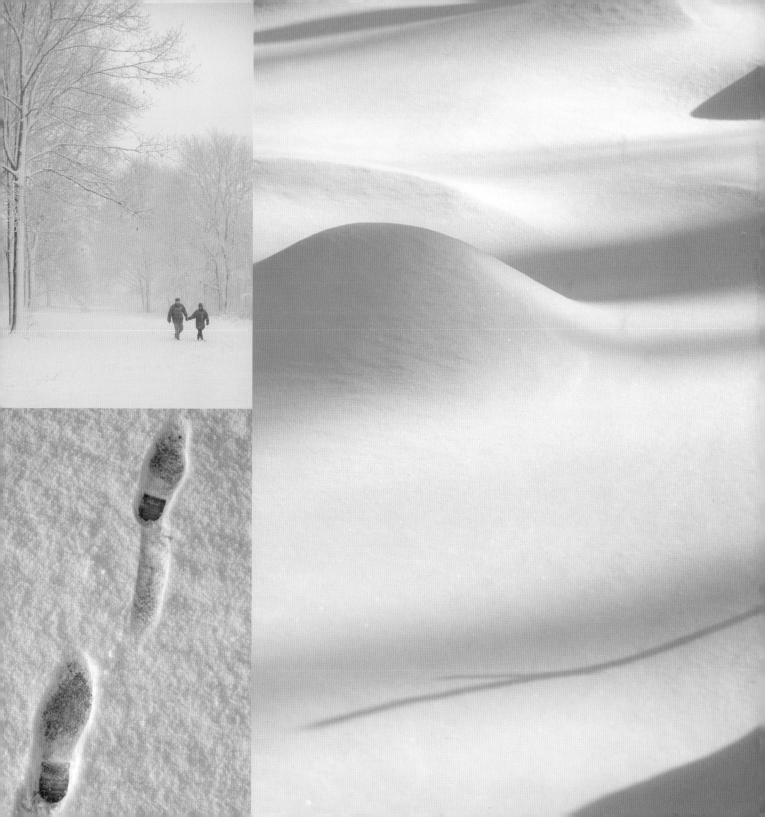

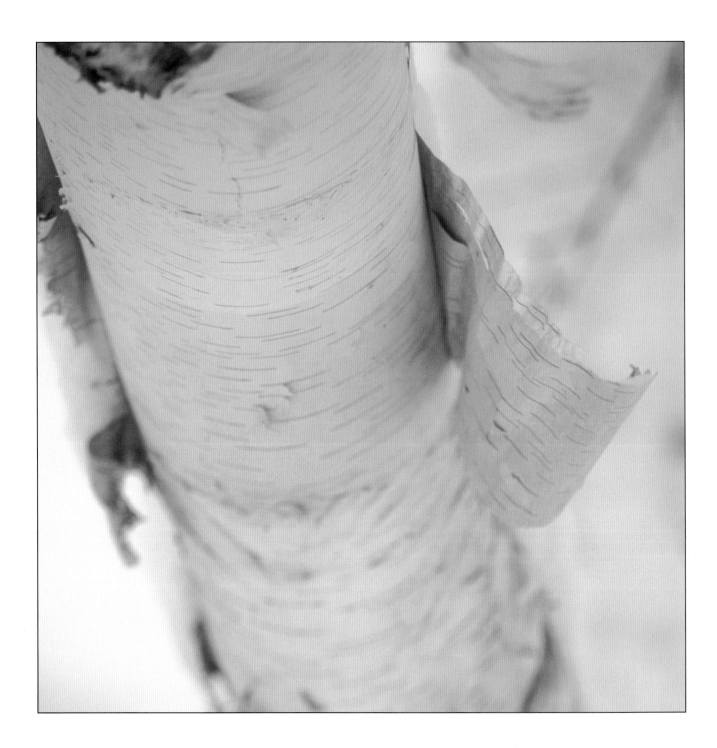

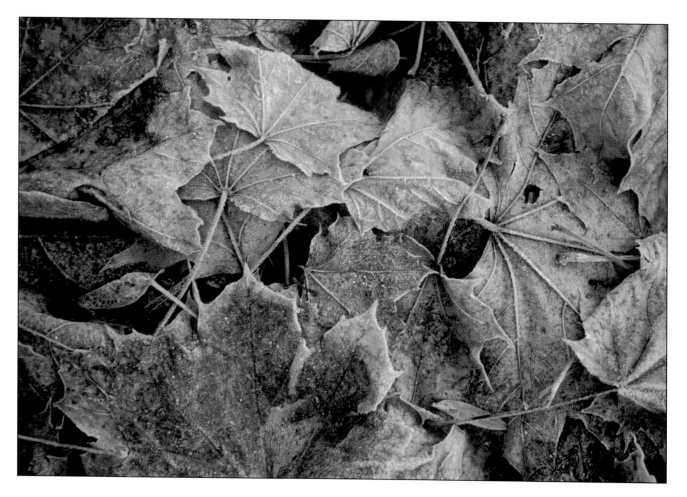

The tendinous part of the mind, so to speak, is more developed in winter; the fleshy, in summer. I should say winter had given the bone and sinew to literature, summer the tissues and the blood.

—*John Burroughs (1837–1921)*
American naturalist and author

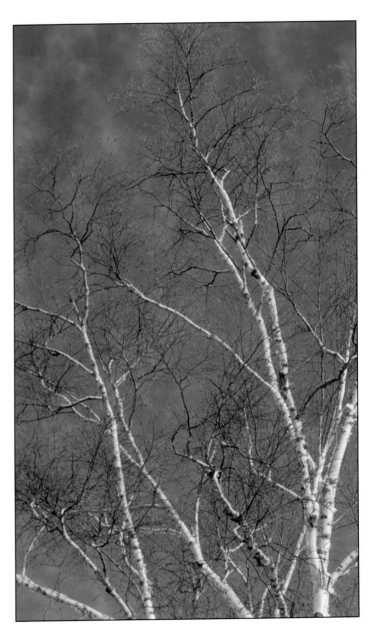

Let us love winter,
for it is the
spring of genius.

—Pietro Aretino (1492—1556)
Italian satirist

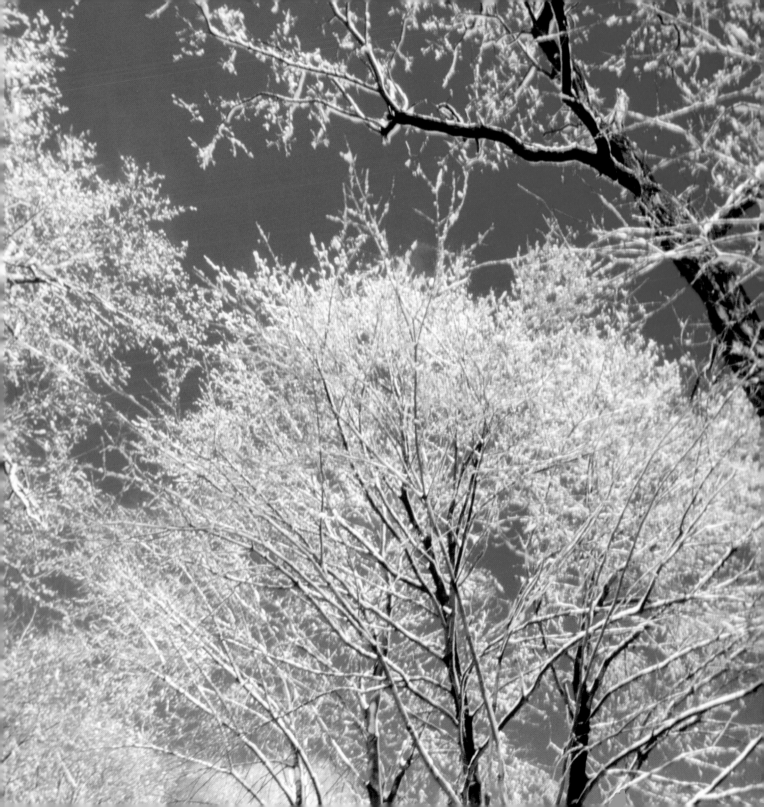

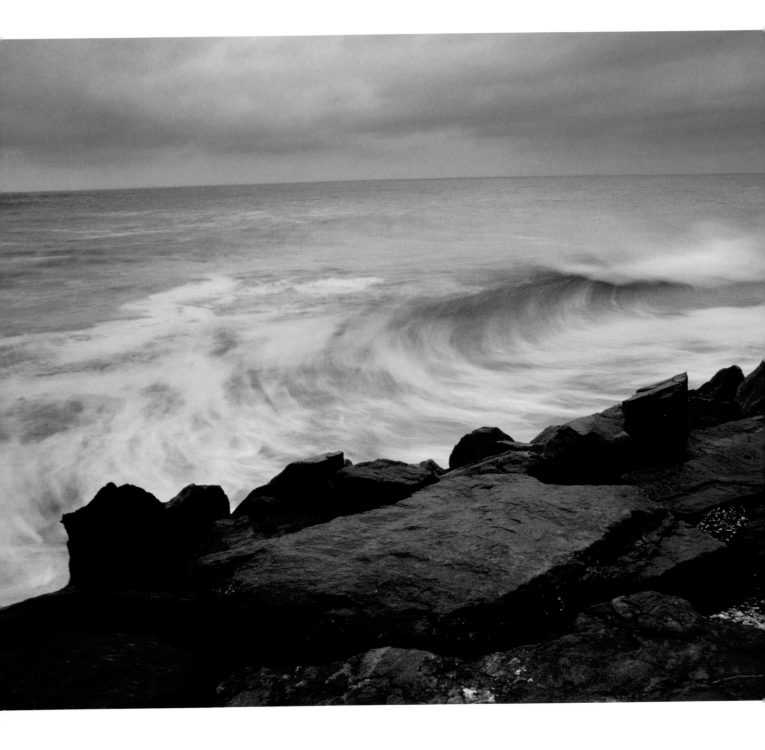

What lies before us and what lies behind us are small matters compared to what lies within us. And when we bring what is within out into the world, miracles happen.

—Henry David Thoreau (1817–1862)

American author and naturalist

Never be afraid
to sit awhile and think.

—Lorraine Hansberry (1930–1965)

American playwright

We grow great by dreams.
All big men are dreamers.
They see things in the soft haze
of a spring day or in the red fire
of a long winter's evening.

—*Woodrow Wilson (1856–1924)*
 American president

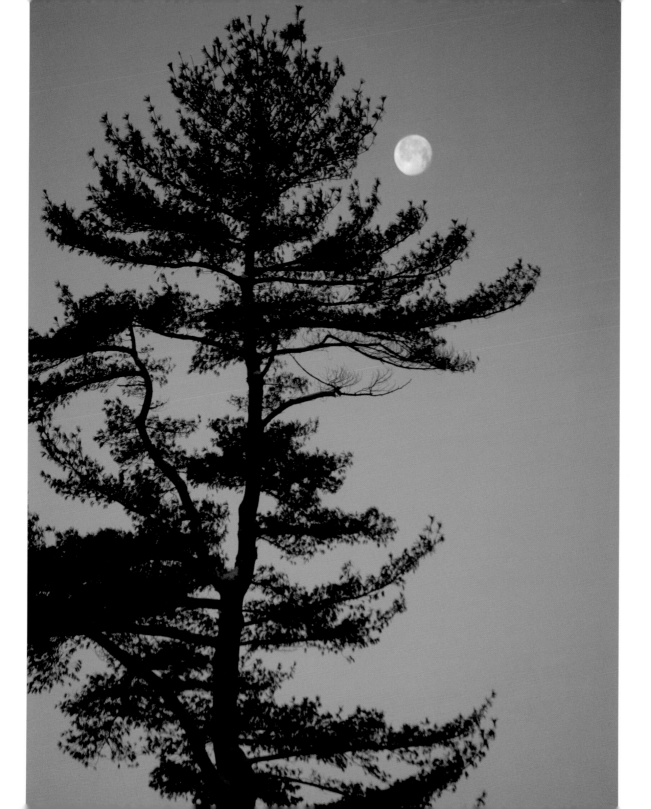

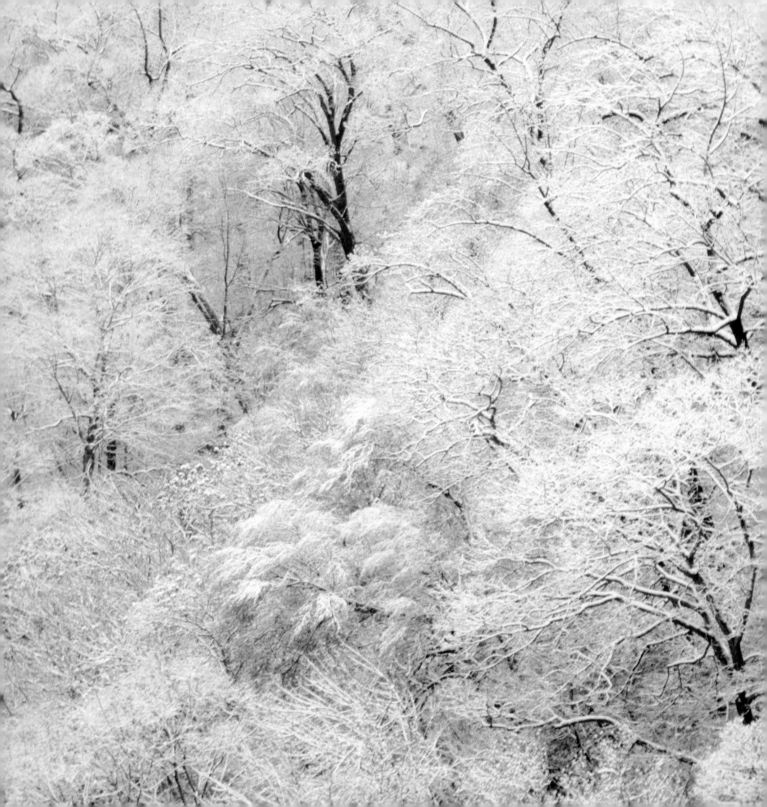

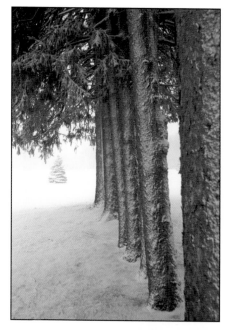

*O for a life of sensations
Rather than of thoughts.*

—John Keats (1795—1821)

English poet

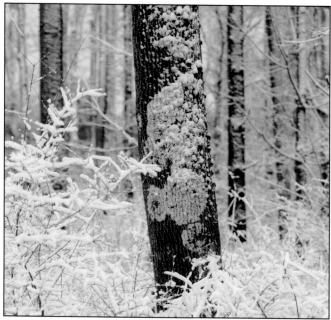

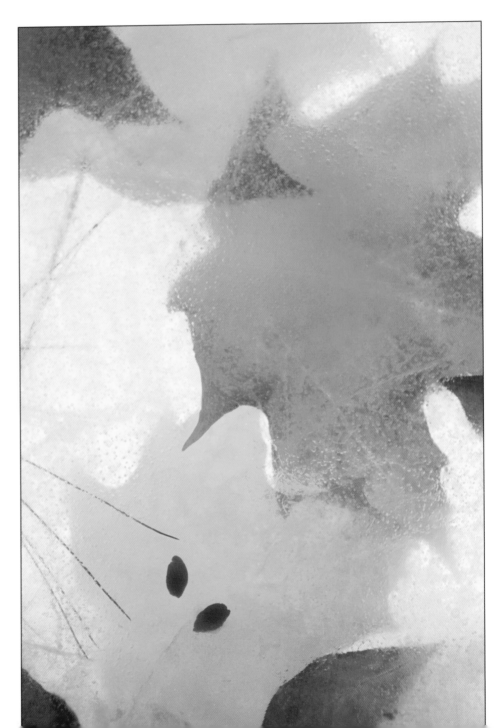

The universe
is change;
Our life
is what our
thoughts
make it . . .

—Marcus Aurelius

(121–180 A.D.)

Roman emperor

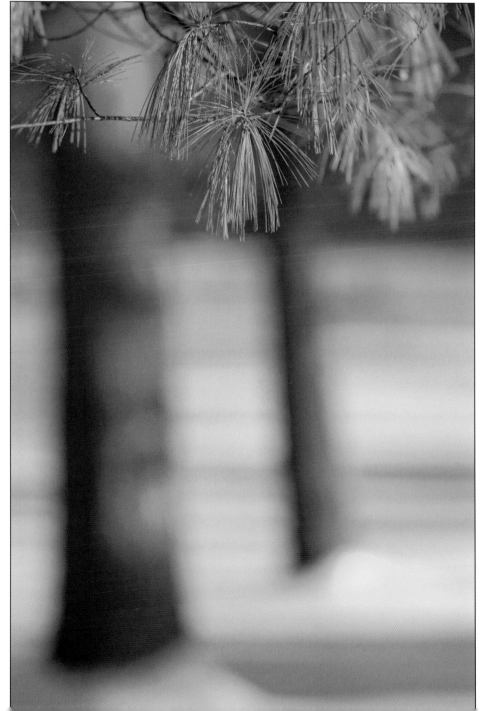

It is only imperfection

that complains of

what is imperfect.

The more perfect we are,

the more gentle and

quiet we become towards

the defects of others.

—*Joseph Addison (1672–1719)*
 English essayist, poet, and statesman

Peace

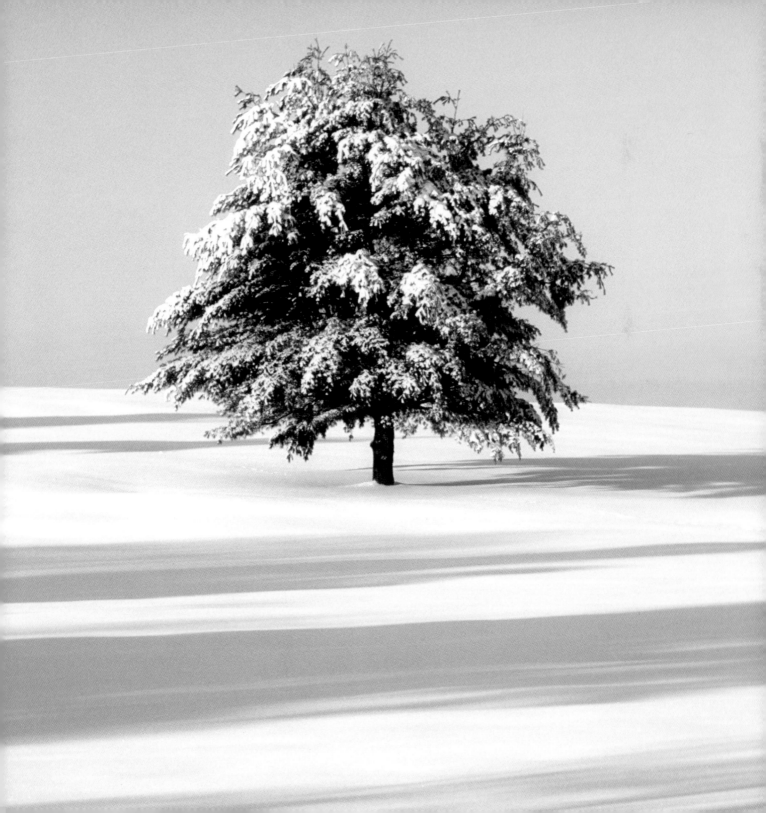

Snow has made everything earthly clear and quiet.

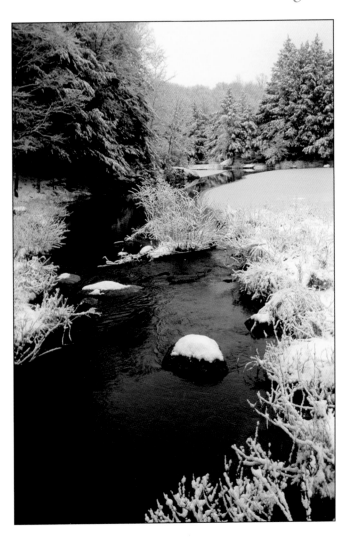

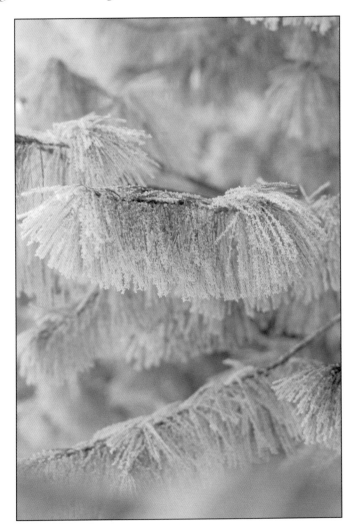

My mind is simple and patient. —Tuomas Anhava (b. 1927) Finnish poet

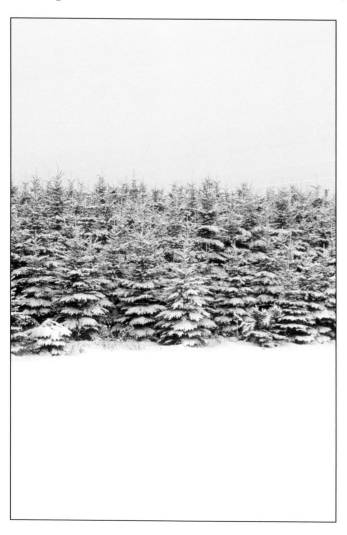

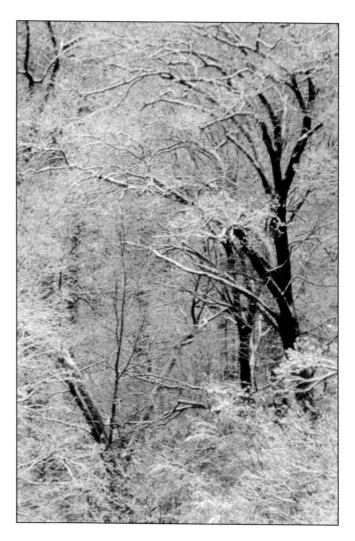

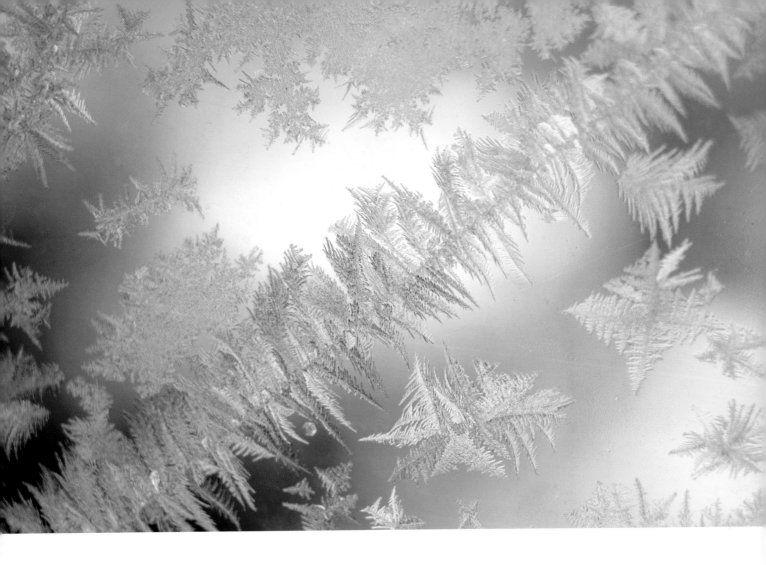

Adversity draws men together and produces beauty and harmony
in life's relationships, just as the cold of winter produces
ice-flowers on the window-panes, which vanish with the warmth.

—*Soren Kierkegaard (1813–1855)*
Danish philosopher

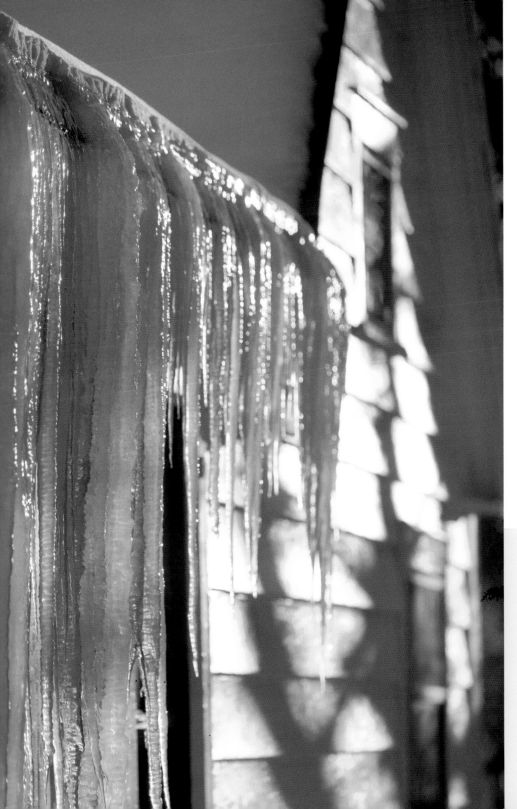

Only when the
clamor of the
outside world
is silenced will
you be able
to hear the
deeper vibration.

—Sarah Ban Breathnach
American author

As soon as you trust yourself,
you will know how to live.

—Johann Wolfgang von Goethe (1749—1832)

German writer, scientist, and philosopher

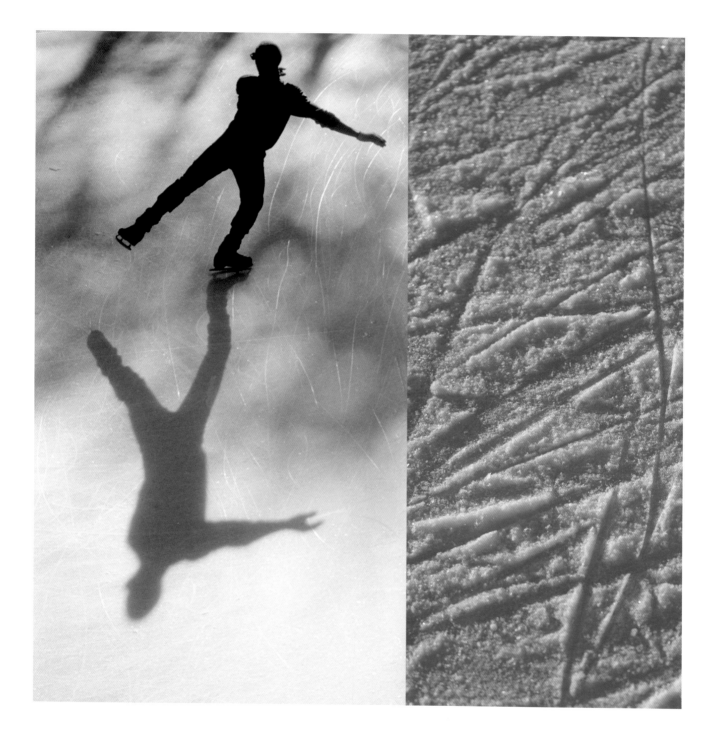

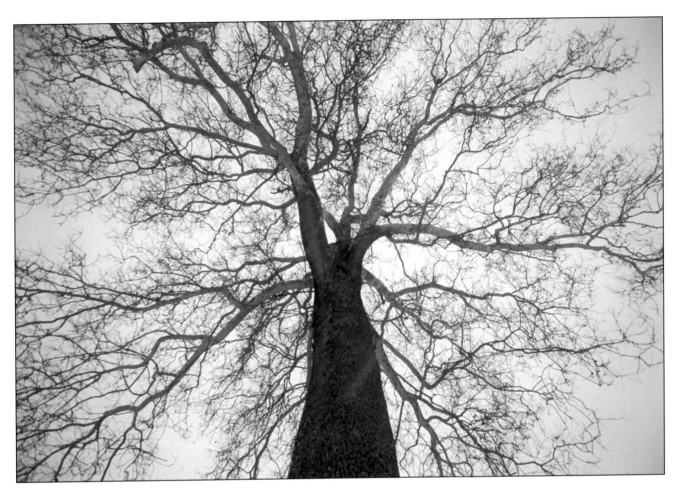

He who lives in harmony with himself
lives in harmony with the universe.

—Marcus Aurelius (121–180 A.D.)

Roman emperor

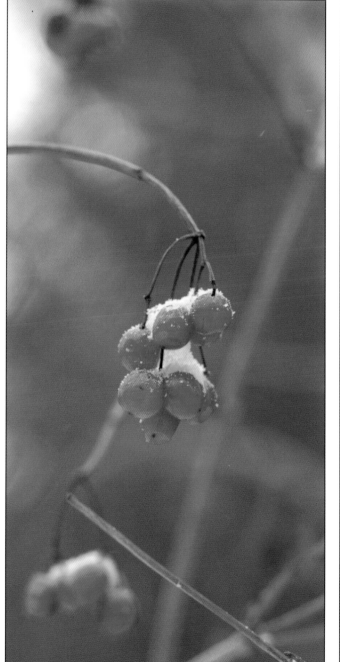
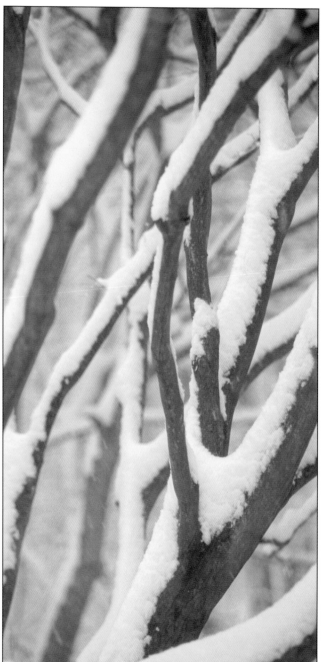

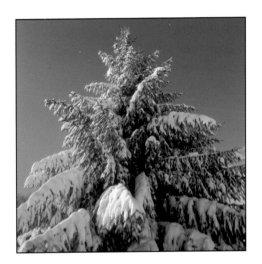

For all practical purposes nature is at a standstill . . .

there is a wonderful joy in leaving behind the noisy city streets

and starting out along the white road that leads across the hills.

With each breath of the sharp, reviving air

one seems to inhale new life.

—*Frances Theodora Parsons (1861–1952)*

 American writer

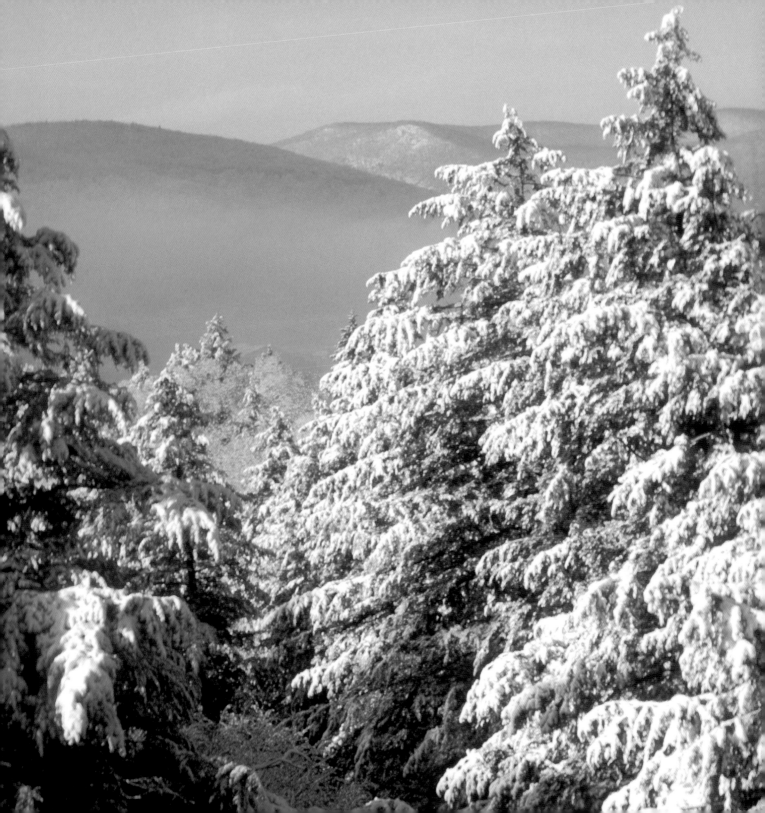

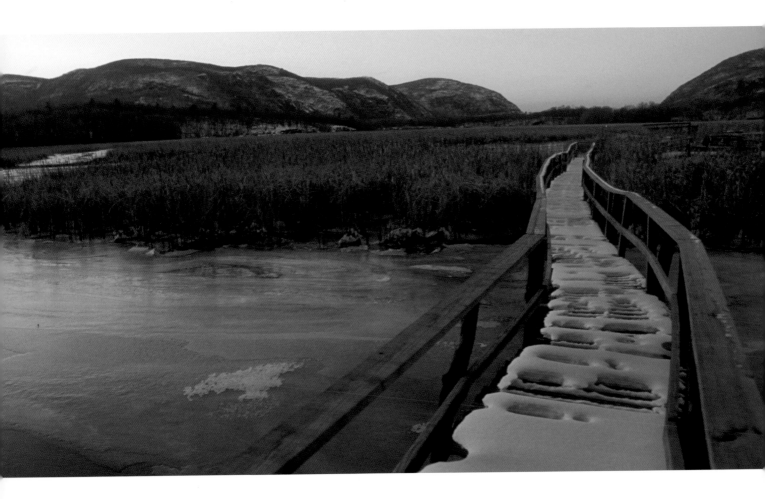

Learn to be quiet enough to hear the sound of the genuine within yourself so that you can hear it in others.

—*Marian Wright Edelman (b. 1939)*
American writer

One must marry one's feelings to one's beliefs and ideas. That is probably the only way to achieve a measure of harmony in one's life.

—Etty Hillesum (1914–1943)
Dutch diarist

Give me beauty in the inward soul; may the outward and inward man be at one.

—*Socrates (c. 470–399 B.C.)*
Greek philosopher

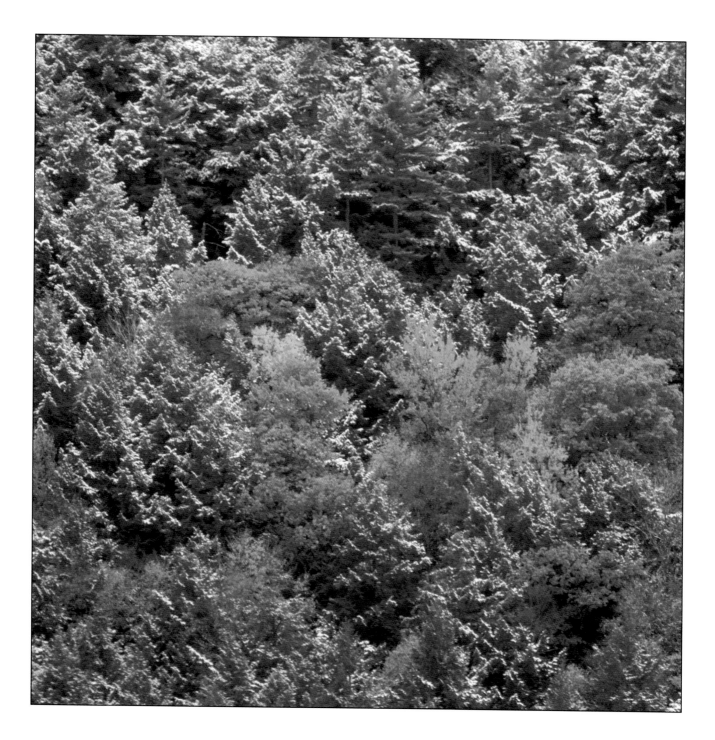

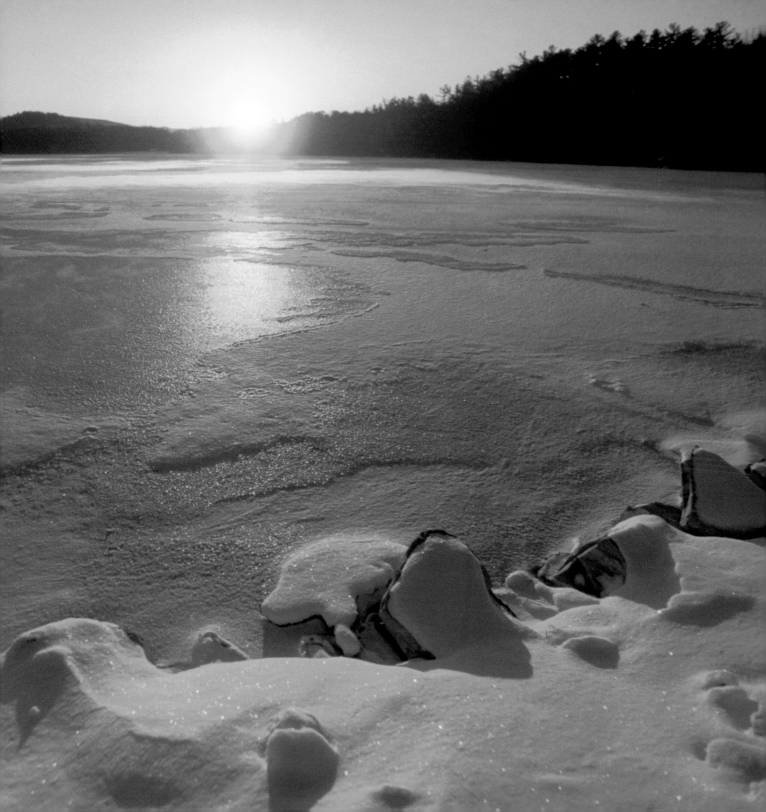

Peace, she supposed, was contingent upon a certain disposition

of the soul, a disposition to receive

the gift that only detachment from self made possible.

—Elizabeth Goudge (1900–1984)

English writer and artist

Nature

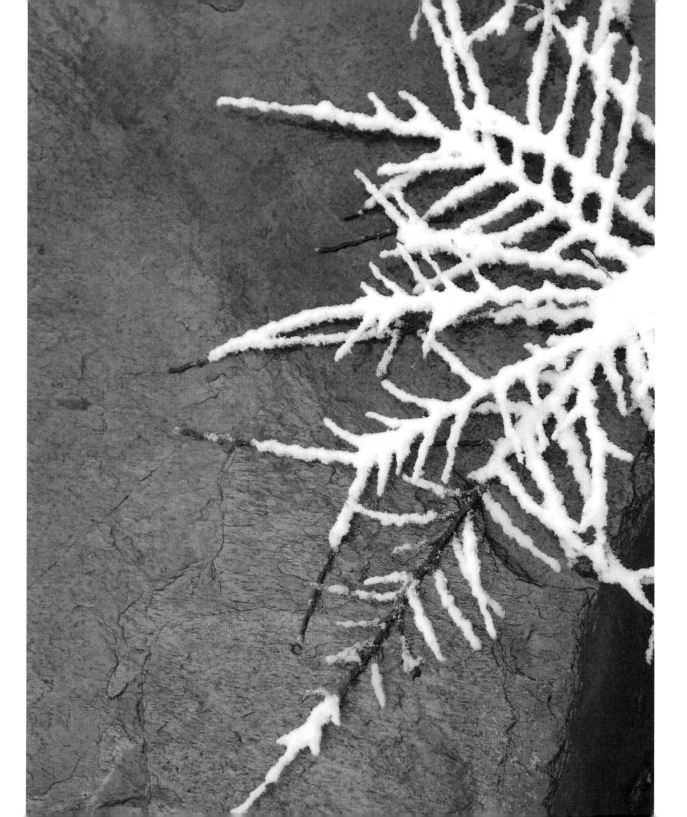

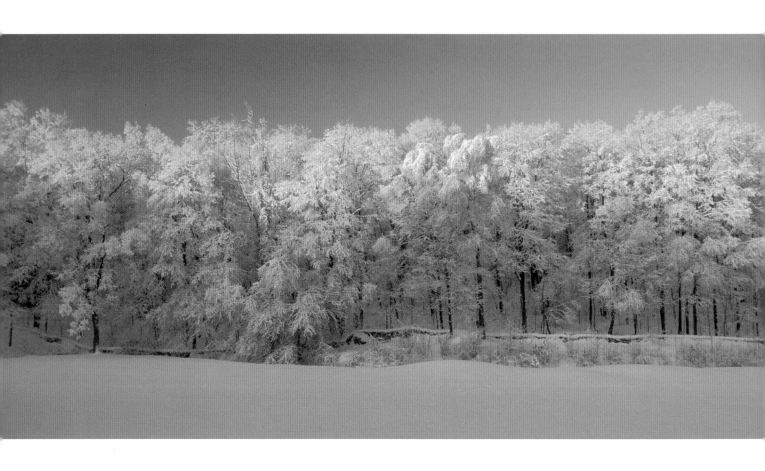

There is nothing in the world more beautiful than the forest
clothed to its very hollows in snow.
It is the still ecstasy of nature, wherein every spray,
every blade of grass, every spire of reed,
every intricacy of twig, is clad with radiance.

—*William Sharp (1855–1905)*
Scottish poet

No one can look at a pine tree in winter
without knowing that
spring will come again in due time.

—Frank Bolles (1856—1894)
American author and naturalist

The goal of life is living in agreement with nature.

—*Zeno of Citium (335–263 B.C.)*
Greek philosopher

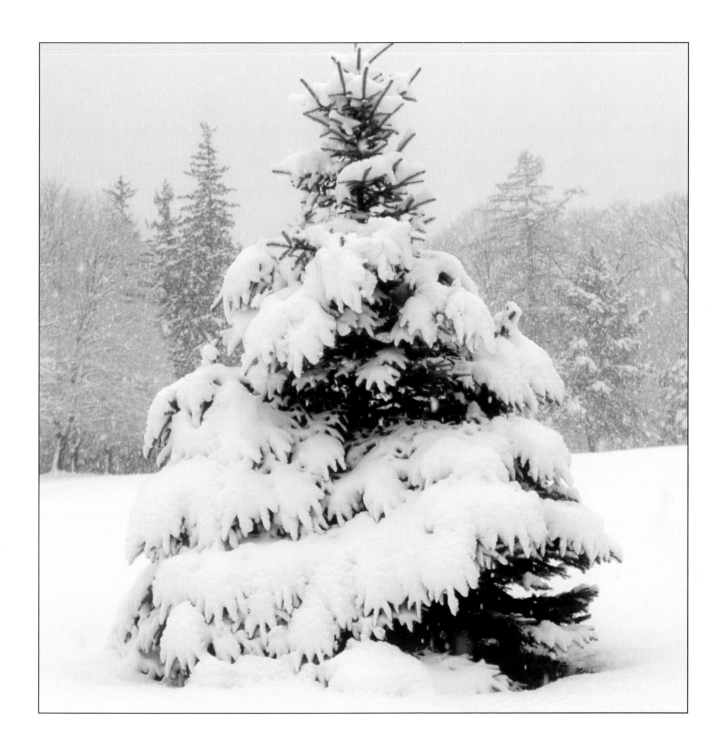

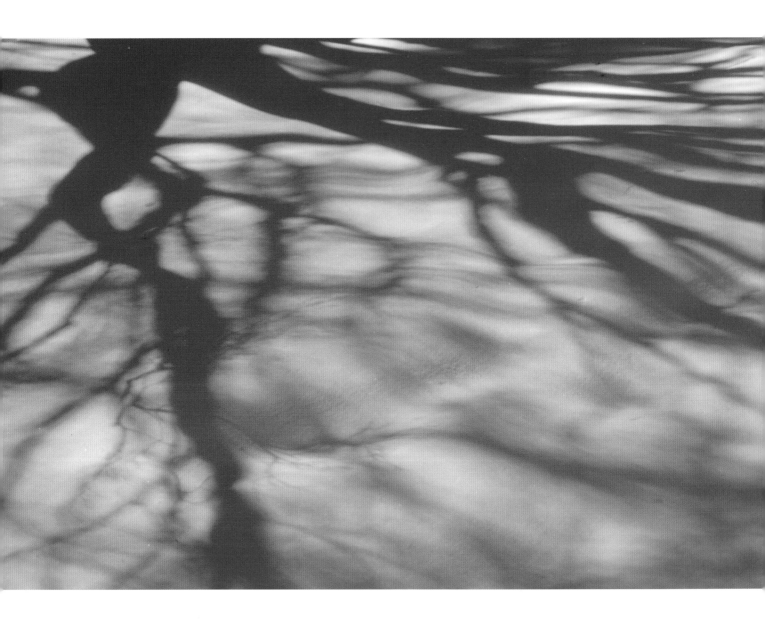

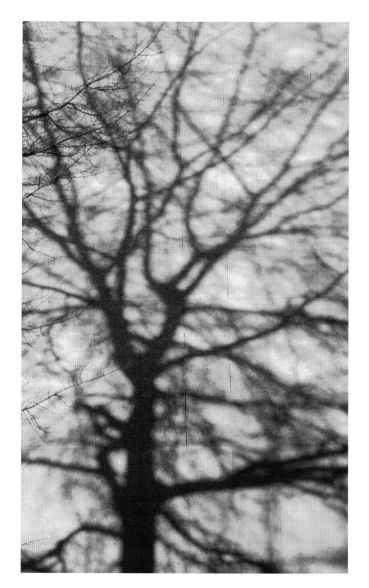

Look round and round upon this bare
bleak plain, and see even here,
upon a winter's day, how beautiful
the shadows are! Alas! it is
the nature of their kind to be so.

—*Charles Dickens (1812–1870)*
English author

Nature gave us one tongue and two ears so we could hear twice as much as we speak.

—Epicetus (c. 55–145 A.D.)
Greek philosopher

Sometimes our fate resembles a fruit tree in winter.

Who would think that those branches would turn

green again and blossom, but we hope it, we know it.

—Johann Wolfgang von Goethe (1749–1832)

German writer, scientist, and philosopher

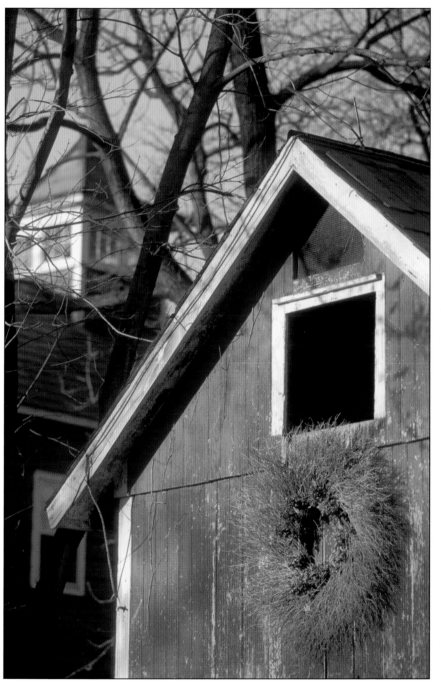
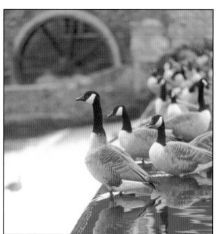
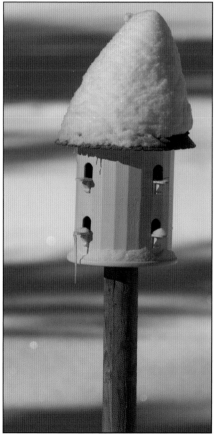

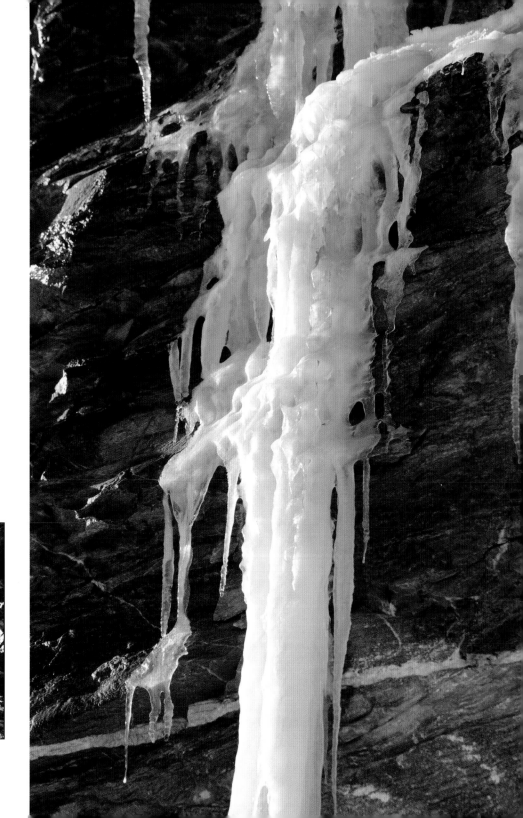

There is no other door to knowledge than
the door Nature opens;
and there is no truth except the truths
we discover in Nature.

—Luther Burbank (1849–1926)
American horticulturist

Art is man
Added to nature.

—Francis Bacon (1561—1626)
English philosopher and writer

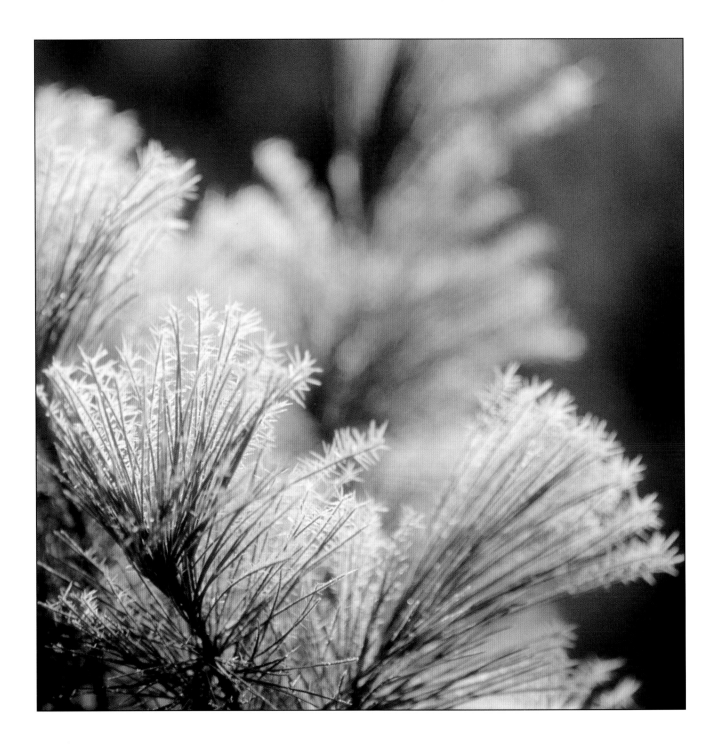

Announced by all the trumpets of the sky, Arrives the snow.

—*Ralph Waldo Emerson (1803–1882)*

American essayist and poet

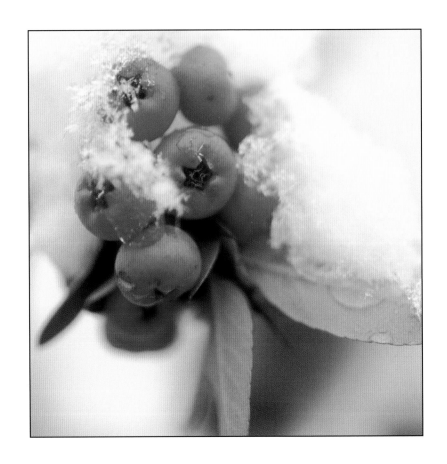

In a way winter is the real spring, the time when

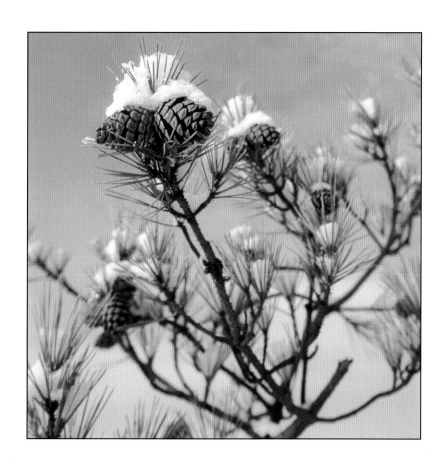

the inner things happen, the resurge of nature.

—*Edna O'Brien (b. 1932)*
Irish writer

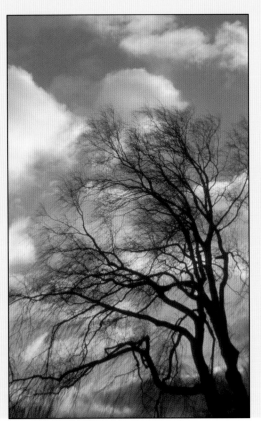

The massy trunks

Are cased in the pure crystal; each light spray,

Nodding and tinkling in the breath of heaven,

Is studded with its trembling water-drops,

That glimmer with an amethystine light.

—William Cullen Bryant (1794–1878)

American poet and editor

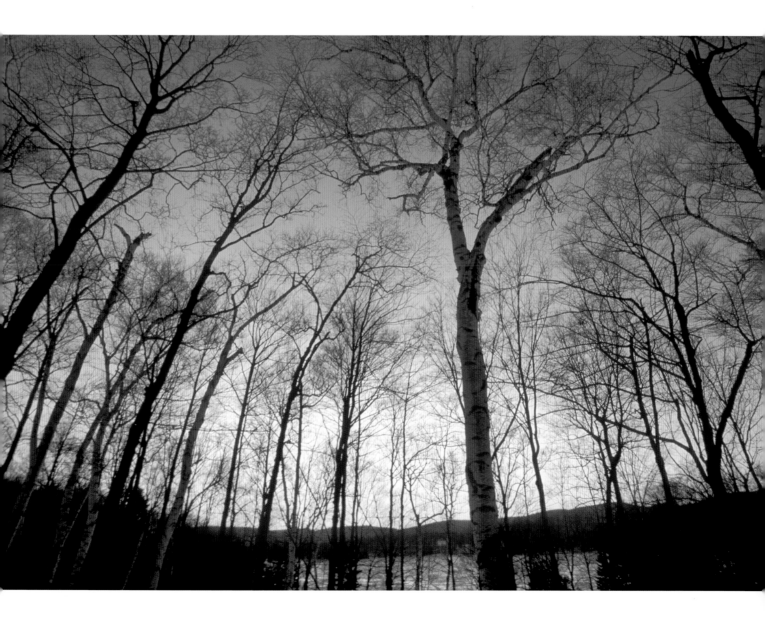

Simplicity

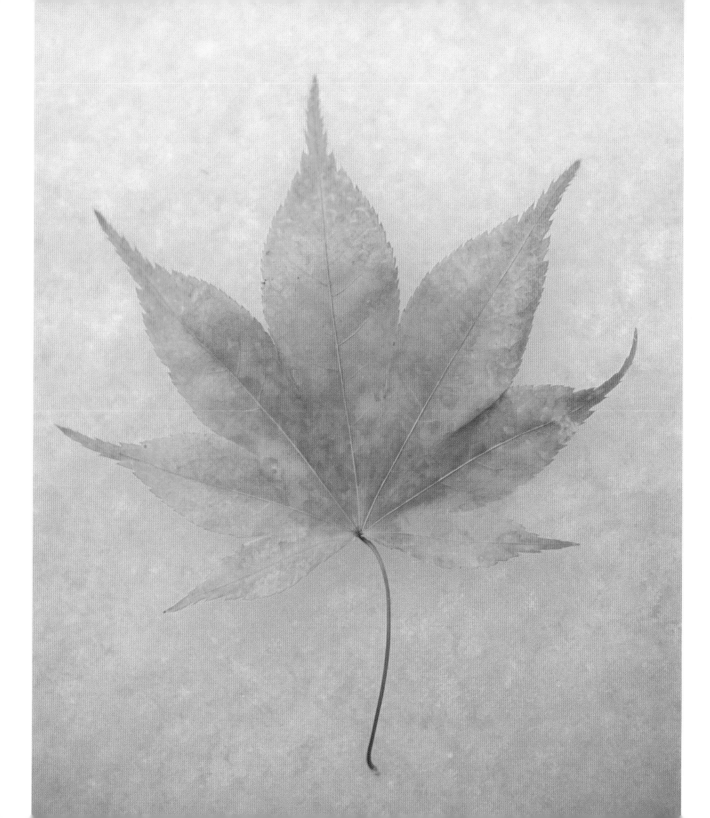

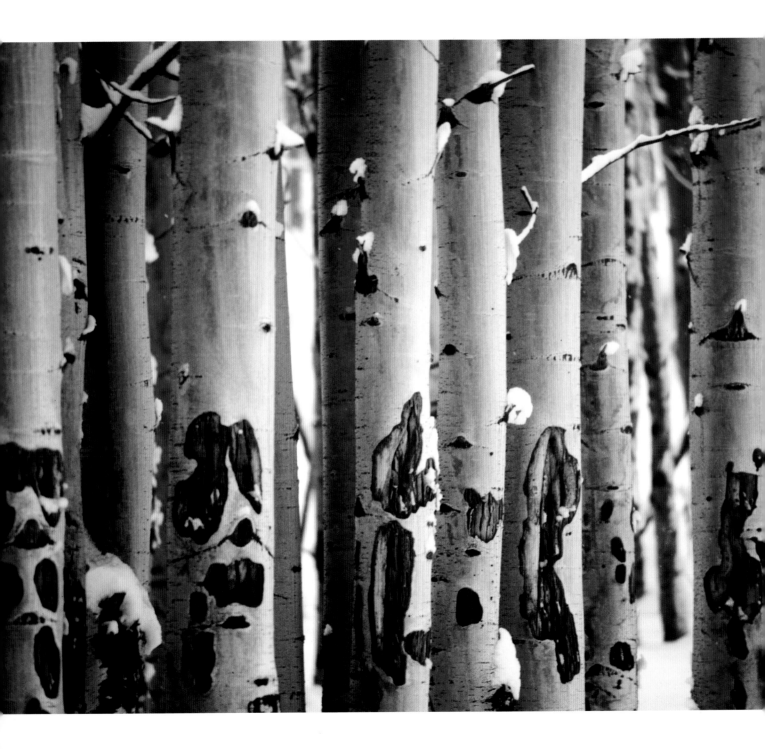

Winter is the time for comfort, for good food and warmth, for the touch of a friendly hand and for a talk beside the fire: it is the time for home.

—Dame Edith Sitwell (1887–1964)
English poet, critic, and biographer

Much wisdom often goes with fewer words.

—Sophocles (c. 496-406 A.D.)

Greek dramatist

Use what talents you possess.
The woods would be very silent
if no birds sang there
except those that sang the best.

—Henry van Dyke (1852—1933)
American clergyman, educator, and author

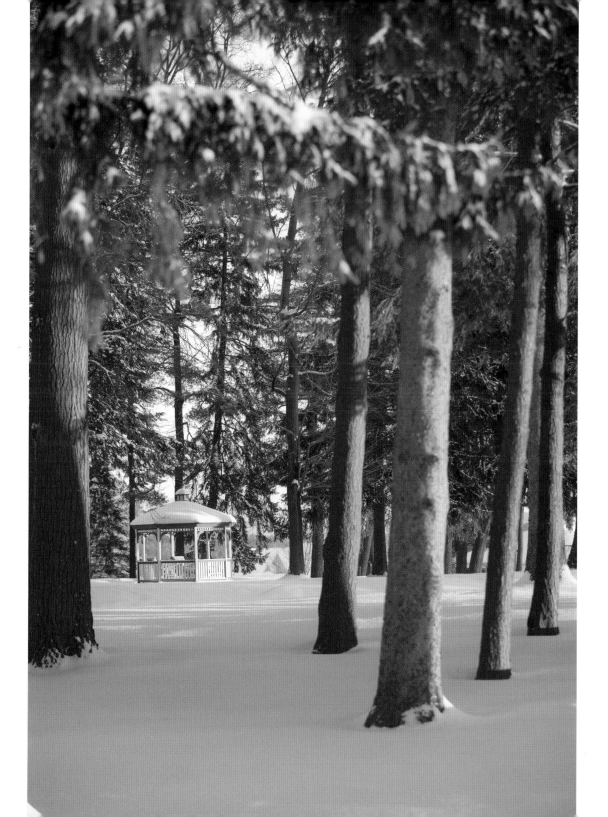

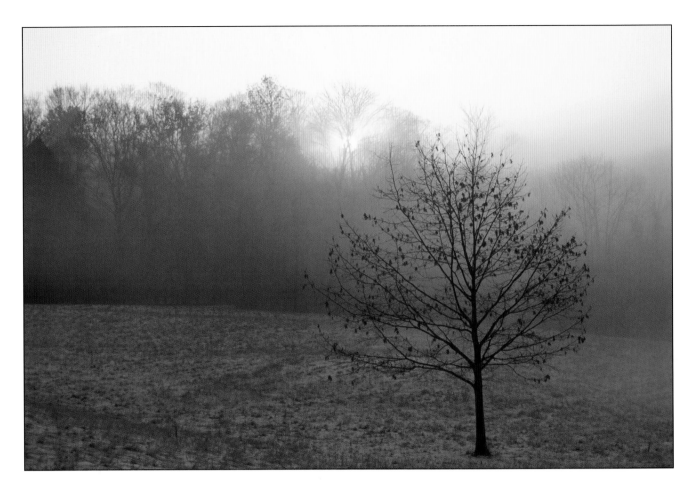

The happiest heart that ever beat was in some quiet breast that found the common daylight sweet, and left to Heaven the rest.

—John Vance Cheney (1848–1922)

American author

Grace groweth best in winter.

—Samuel Rutherford (1600–1661)

Scottish clergyman

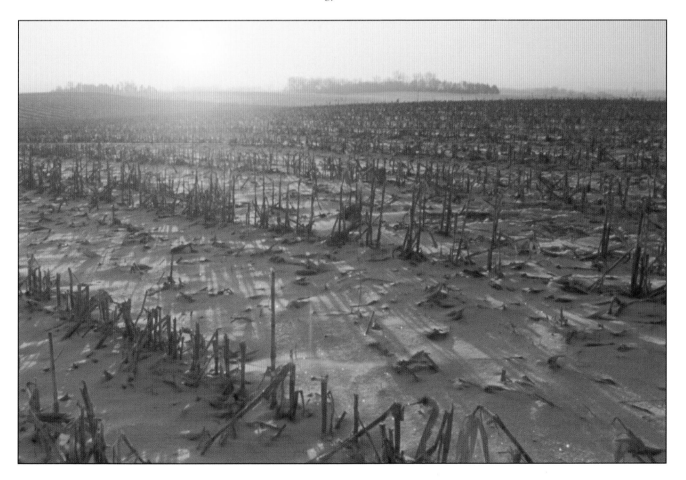

The frost performs its secret ministry,
Unhelped by any wind.

—*Samuel Taylor Coleridge (1772–1834)*
English poet

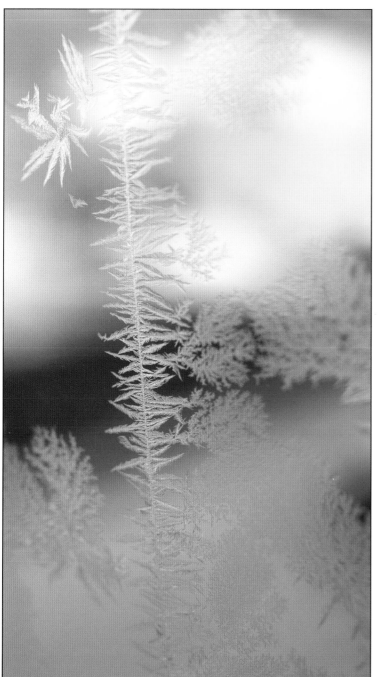
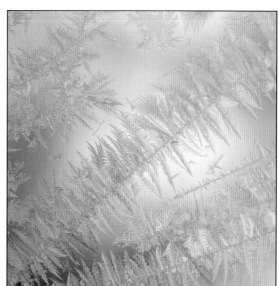
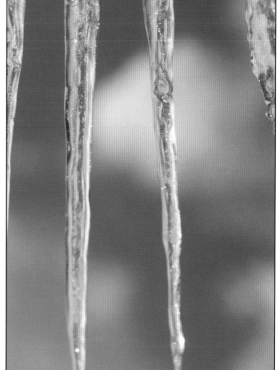

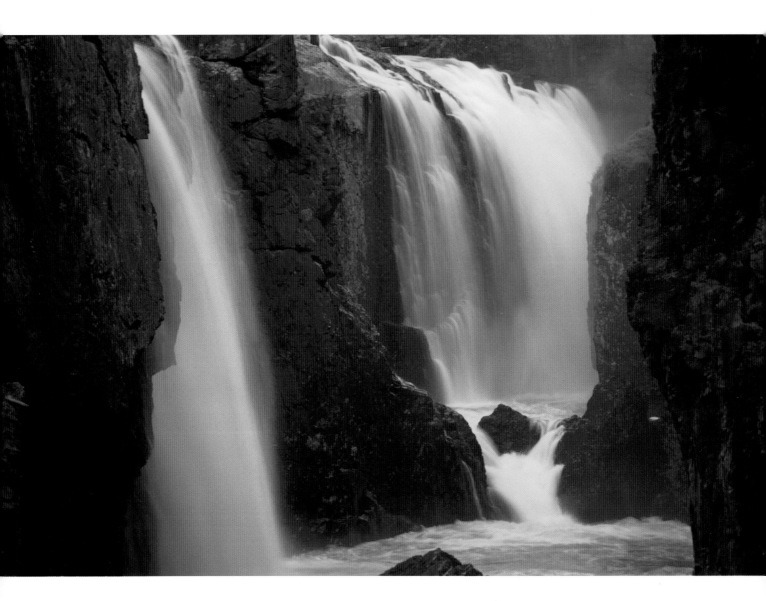

Most of the luxuries, and many of the so-called comforts

of life, are not indispensable, but positive hindrances

to the elevation of mankind. With respect to

luxuries and comforts, the wisest have even lived

a more simple and meager life than the poor.

—Henry David Thoreau (1817–1862)

American author and naturalist

To become a happy person,

have a clean soul,

eyes that see romance in the commonplace,

a child's heart,

and spiritual simplicity.

—Norman Vincent Peale (1898—1993)

American cleric and writer

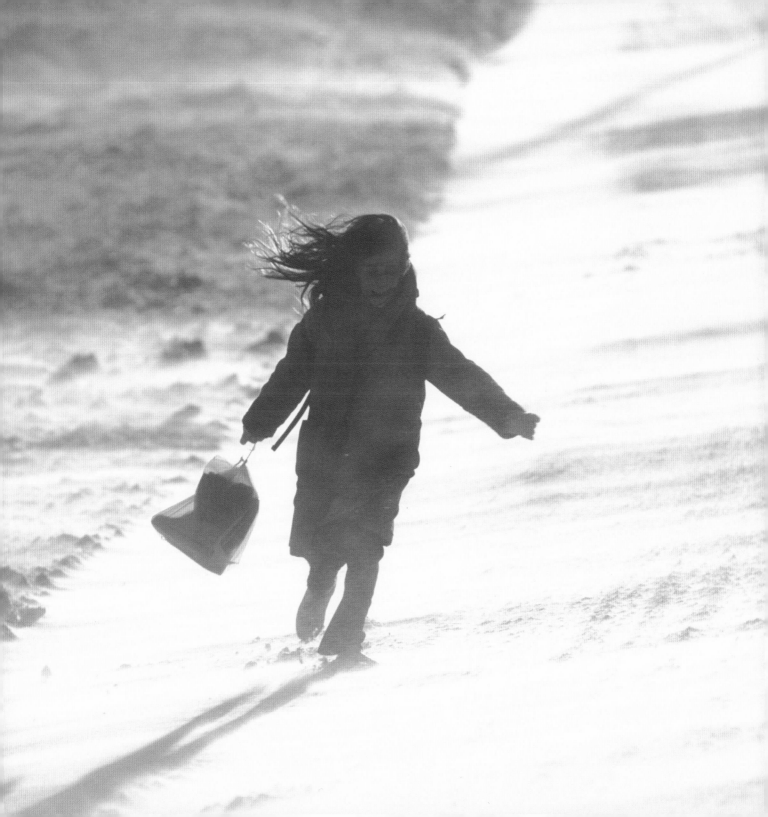

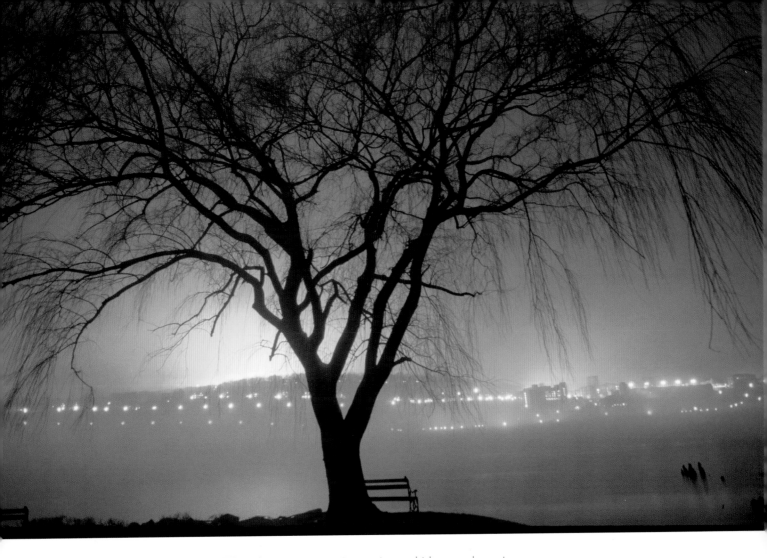

To be content with what we possess
Is the greatest and most secure of riches.

—Marcus Tullius Cicero (106–43 B.C.)

Roman orator, statesman, and philosopher

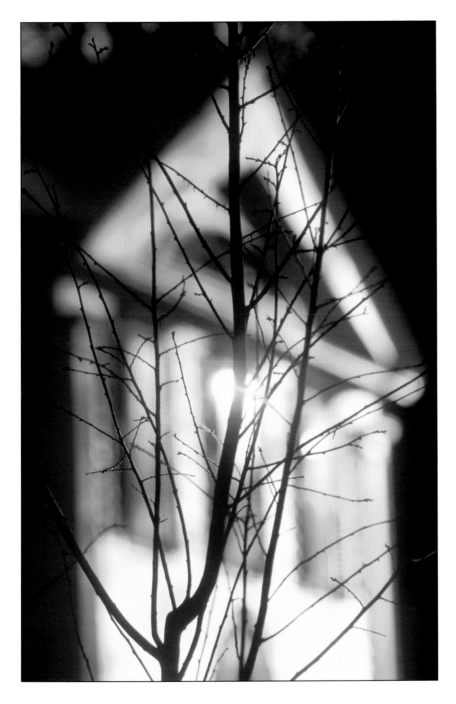

What
fire
could
ever
equal
the
sunshine
of a
winter's day?

—*Henry David Thoreau (1817–1862)*
American author and naturalist

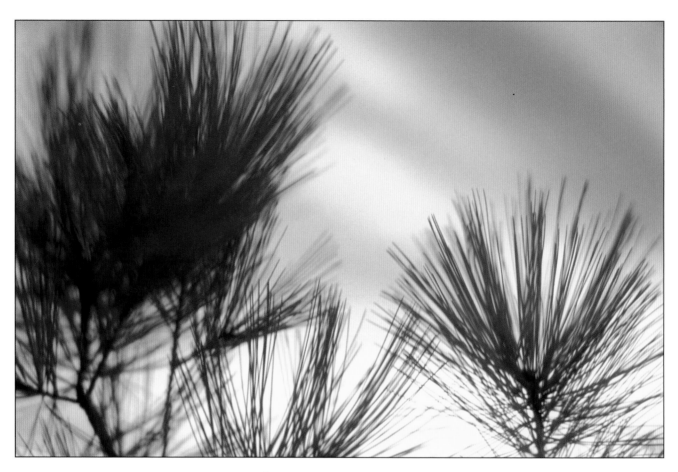

Simplicity is the ultimate sophistication.

—*Leonardo Da Vinci (1452–1519)*

Italian painter, sculptor, and scientist